Edward Hopper

Summer at the Seashore

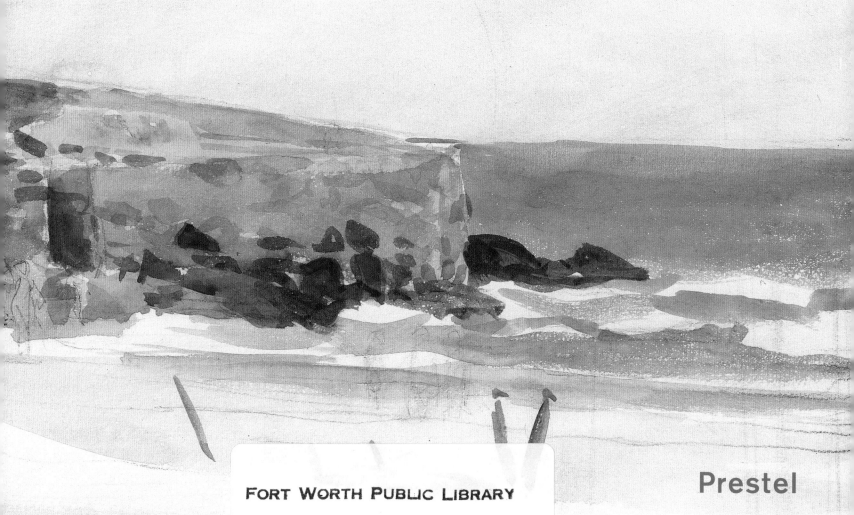

Prestel

From the City
to the Sea

Edward Hopper was an artist who lived most of his life in New York. Although he is especially famous as a painter of the city—and of the lonely people living there—he also painted many pictures at the seashore.

Hopper was fascinated by the city—not the shiny new city of skyscrapers, but the older, more worn-down neighborhoods. Instead of the busy hustle and bustle, he preferred to paint the "between times" in the city when the streets were empty, and the bright morning light shone on the old, red brick buildings.

Early Sunday Morning

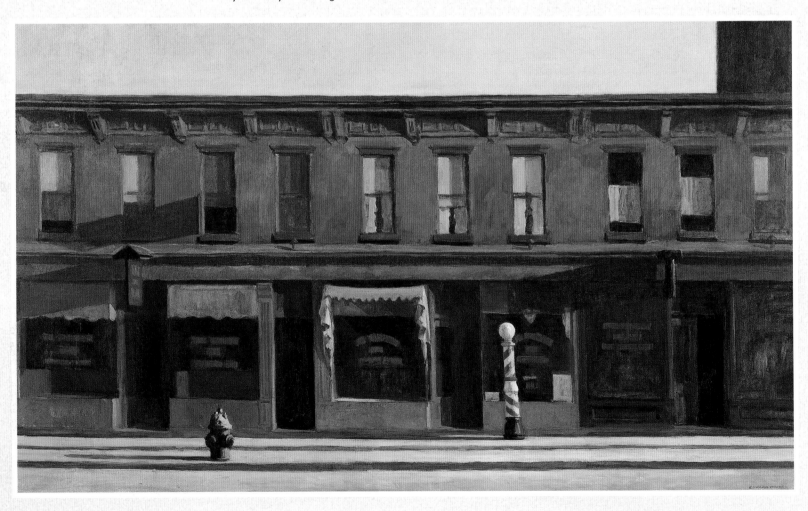

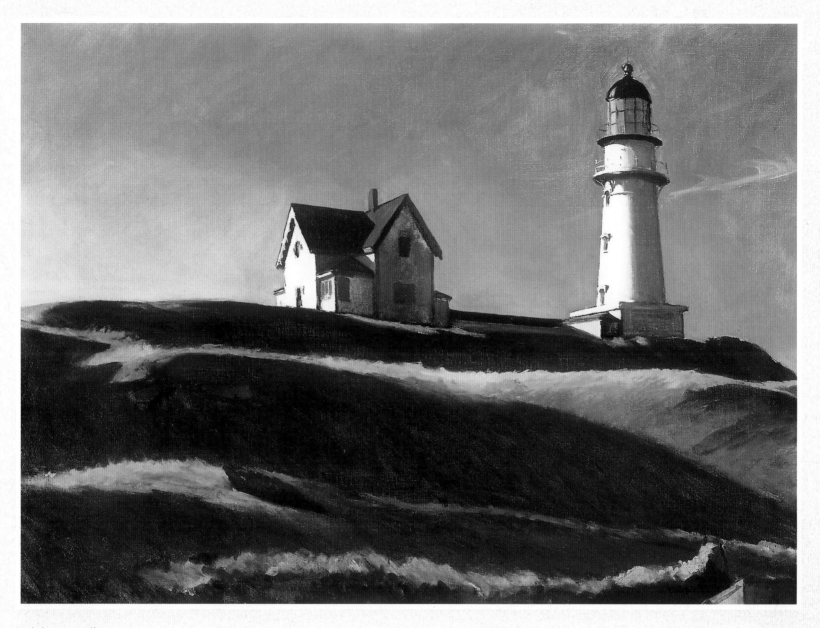

Lighthouse Hill

Hopper loved the seaside in the same way. He was less interested in scenes of bathers on the beach than in the weathered buildings, all bleached by the wind and the sun, and the rough beauty of the east coast of America. To escape from New York, Hopper and his wife Jo would pack up their old car most summers and drive off to the seaside, where he painted lots of sun-filled pictures of the New England coastline.

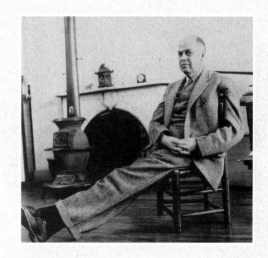

Edward Hopper in his
New York studio, 1938

The Boy Who Loved Boats

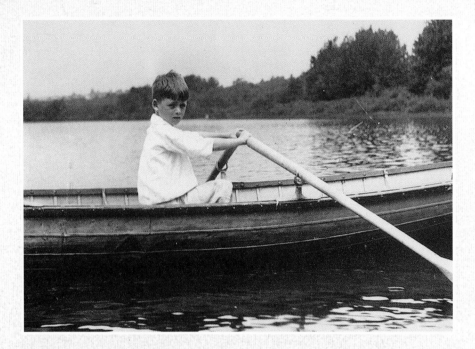

Edward Hopper as a child in a rowboat, Nyack

Hopper grew up just north of New York City in the small town of Nyack, on the shores of the Hudson River. When he was a child, he loved to watch the boats sailing down the river. That was more than one hundred years ago, when a great many passed Hook Mountain—not only sailboats, but working boats carrying cargo up and down the coast. Nyack also had shipyards, and Hopper and his friends spent a lot of time there.

Sketches of boats and fishing tackle

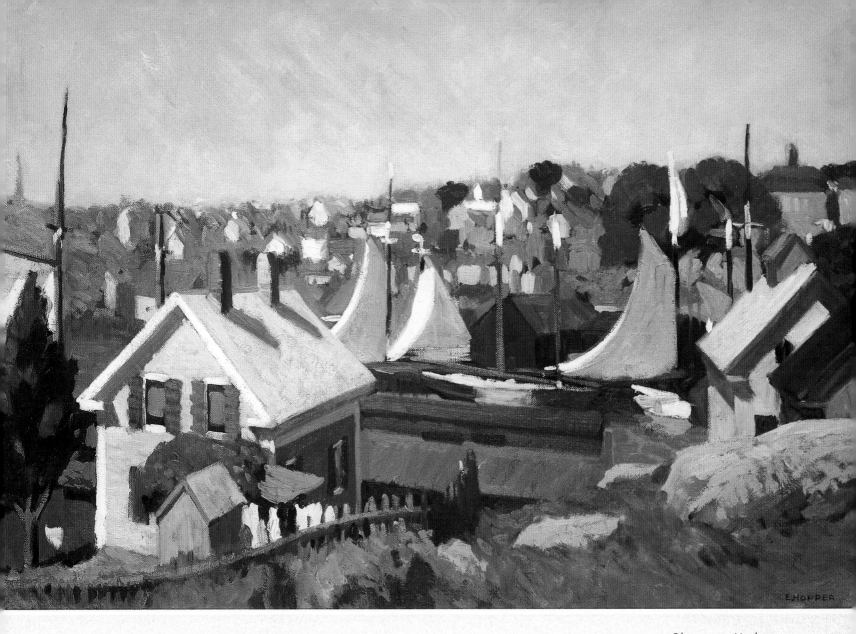

Gloucester Harbor

Like many children, he liked to draw the things he saw and things he dreamed up—so sometimes faces pop up in his drawings of boats, or boats turn into buildings! Hopper also built his own boat when he was a teenager, and even thought about making his living as a boat designer.

In Gloucester, Massachusetts, which Hopper visited as a young man, he painted the sailboats that entered the harbor. When he was just starting out as an artist, he used lots of paint on his canvases. Because the paint is so thick, the sailboats look as stiff and solid as the white roofs in the town. The buildings in the background are shown just by simple dabs of white paint from his brush. The sun is very bright and the shadows dark, and the roofs, and sails, and masts, and buildings all create a cheerful rhythm.

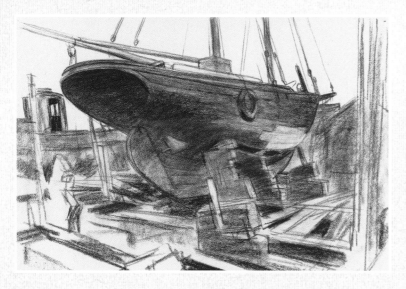

Sailboat in Dry Dock

Work and Play at the Seashore

Gloucester was not only a place where tourists like to stay, it was also an old fishing port. When Hopper later returned to the town, he spent a lot of time roaming the streets, painting the houses where the fishermen lived. In the coastal towns he visited in Massachusetts and Maine, he also painted the fishing boats and the boatyards he had loved so much as a child. Many times he painted close-up views of the bows and the decks of these boats—hardly showing the water at all. He liked the lines and angles of all the equipment found on these old boats, which had seen many years of service at sea.

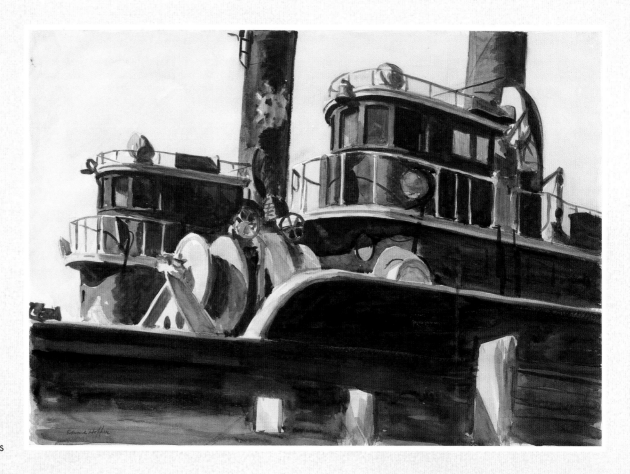

Two Trawlers

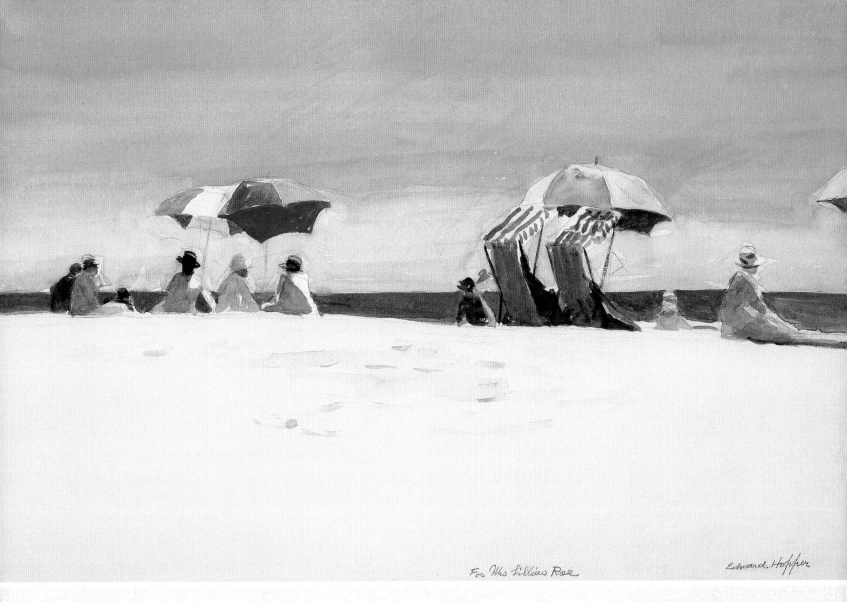

For Mrs Lillias Roe Edward Hopper

Gloucester Beach, Bass Rocks

When Hopper visited Gloucester in 1924, it was with his wife, the painter Josephine Nivison, whom he had married in July that year. They spent their honeymoon near the beach at Bass Rocks, where Hopper painted this picture. This is one of the few times that he painted a scene of people relaxing on the beach, instead of just ropes, boats or old houses. It is a calm and gentle scene. Like his pictures of the fishing boats, it is a watercolor, in which the paint has been put on very lightly. The figures have been kept very simple like the rest of the composition—the way the scene is laid out on the paper. There are three main bands of color—for the sky, the water, and the sand—with bright colors used to pick out the umbrellas and striped chairs. Hopper liked to keep things simple.

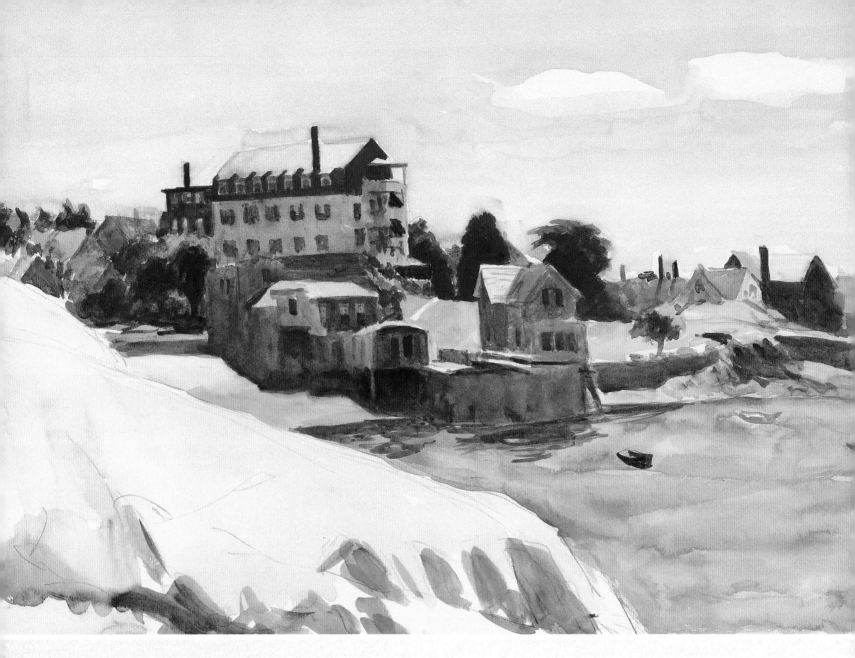

Small Town on Cove

Jo and Edward

Painting
Outdoors

Most of the pictures Hopper is best known for were painted indoors in his studio, as he worked mostly in oil, making up his pictures both from things he'd seen, and from things he'd dreamed up in his head. But watercolor paintings like these shown here were often done on the spot in the open air.

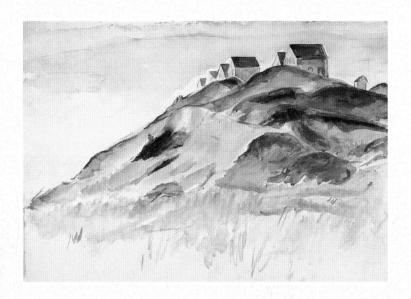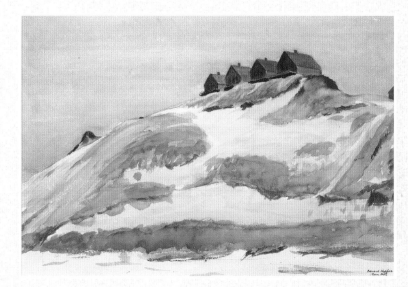

Two views of Corn Hill: *left* by Jo and *right* by Edward Hopper

Especially in the years after the two artists were first married, Jo and Edward would spend time painting outdoors, often picking the same subjects. In the painting at left, which he actually never finished, we can see the pencil marks he made when he sketched out the scene and then colored it with a wash of watercolor—lots of the white paper still shows, which makes it seem full of light.

Jo Sketching at Good Harbor Beach

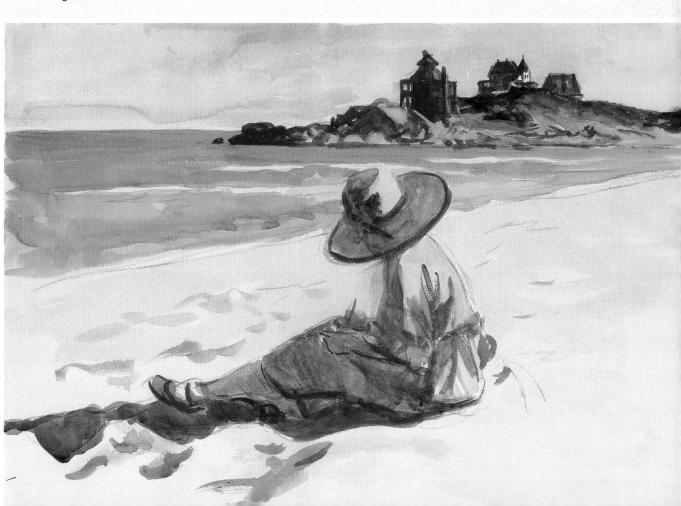

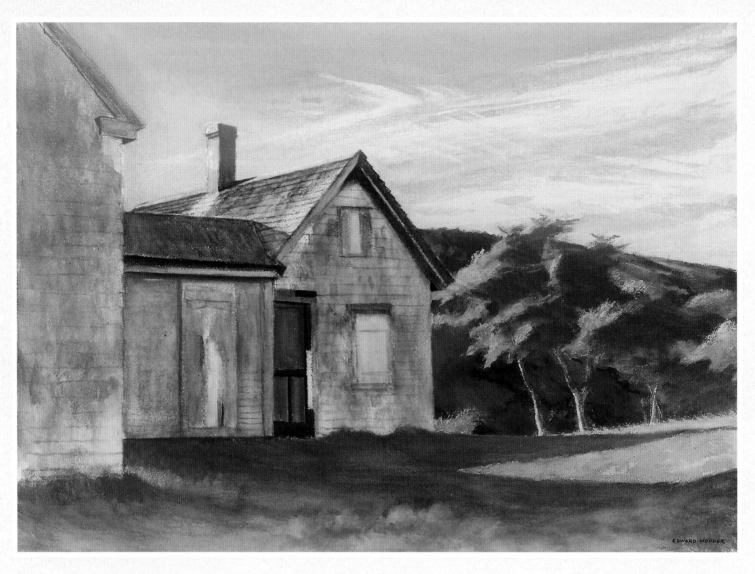

Cobb House

Landscape and Light
on Cape Cod

Hopper loved the intense light of the New England coast, and he particularly liked the light on Cape Cod, a peninsula in Massachusetts. Edward and Jo started spending summers at Cape Cod in 1930. They chose to stay at the far end, close to the artists' colony of Provincetown, in a little place called Truro, where the land was treeless, and where Hopper said there were "fine big hills of sand." After a few years they decided to build a house there, on top of a hill right next to the bay.

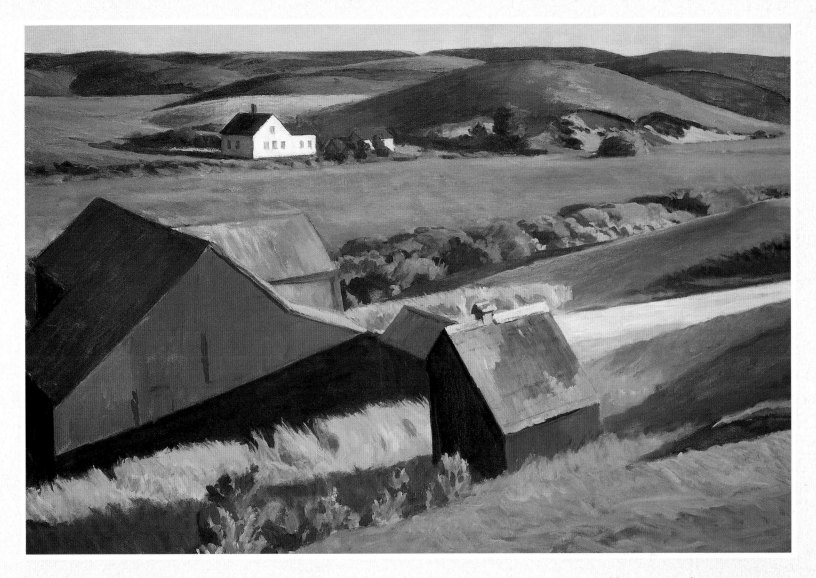

Cobb's Barns and Distant Houses

B efore the Hoppers built their own house, they stayed in a little cottage on Mr. Cobb's farm. Here you can see the wonderful light in the countryside that Hopper knew so well. The old farm buildings nestle comfortably among the soft hills, rounded by the gentle late afternoon light. The low sun throws long shadows, drawing stripes across the land. You can hardly see the sky at all, yet you can tell that the sun is close to the horizon. It is a sleepy and quiet time of day in the country.

Hopper on Cape Cod
in 1934

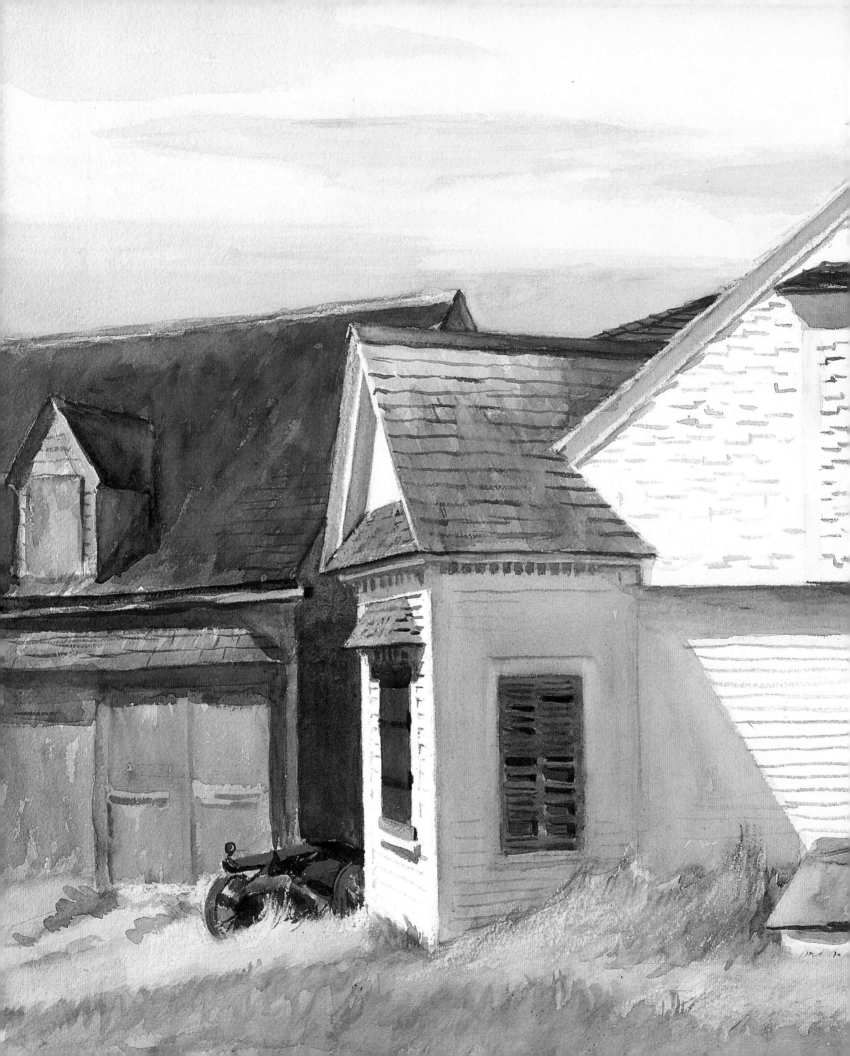

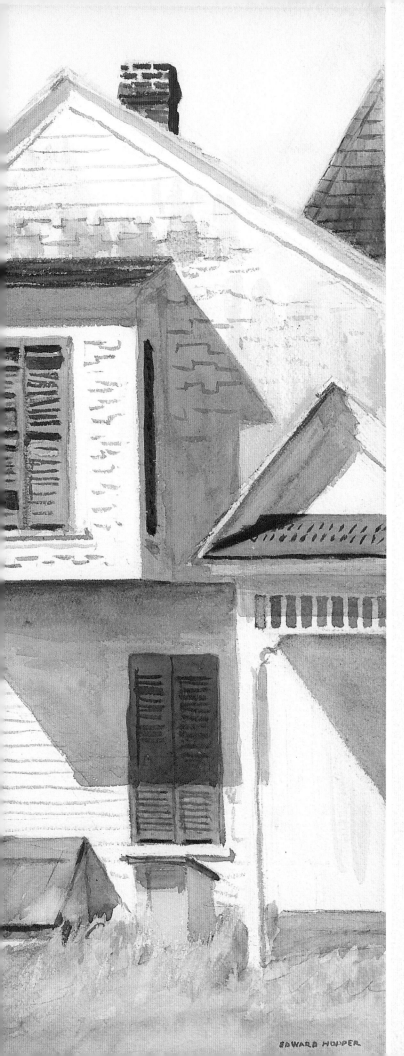

EDWARD HOPPER

Painting Buildings

J o once complained that her husband chose the least attractive scenes to paint in the places they visited in the summer. Hopper liked the ordinary; he liked the places where people lived and worked, and he liked the effects of time and weather—very few things in a Hopper painting look new. He certainly picked unusual subjects sometimes while at the seashore, as not many artists would have chosen to paint outdoor toilets, sheds, or old fishing traps!

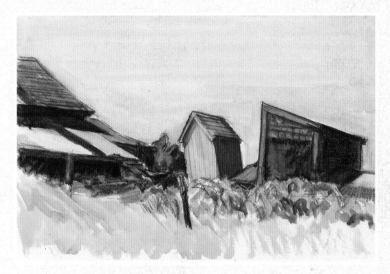

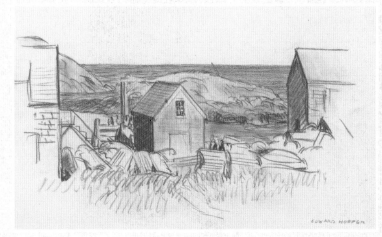

left: House on Pamet River

Lighthouses

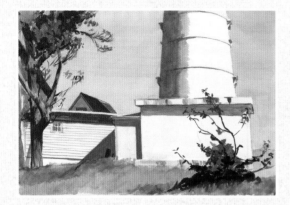

Again and again Hopper painted the lonely lighthouses that stand watch over the boats that enter the ports. Sometimes he painted the same lighthouse many times over from different angles. He was a practical, no-nonsense kind of person, who liked useful things. We can easily imagine how he must have loved lighthouses, which are beautiful in a plain sort of way. Just as most of the boats Hopper painted were working boats, here was a working building. It certainly wasn't luxurious either.

Hopper didn't just paint the tall lighthouses, framed against the sea and sky—he was interested in the keepers' houses just as much. In the picture above, he painted the buildings that had been added to a lighthouse. Only the bottom of the lighthouse is visible. As in many of his paintings, the light is very clear and bright. We can't see the water, but can sense that it is not far away. Although boats now use radar to keep away from the cliffs or sandbanks, lighthouses are still very much part of the coastline.

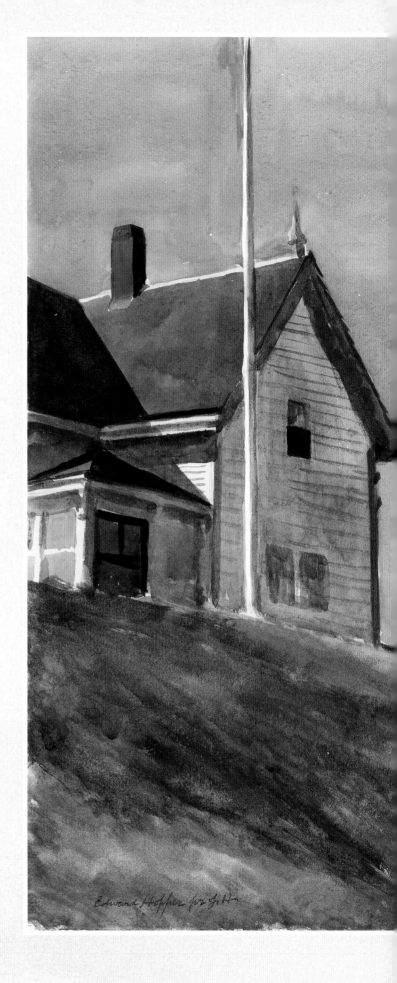

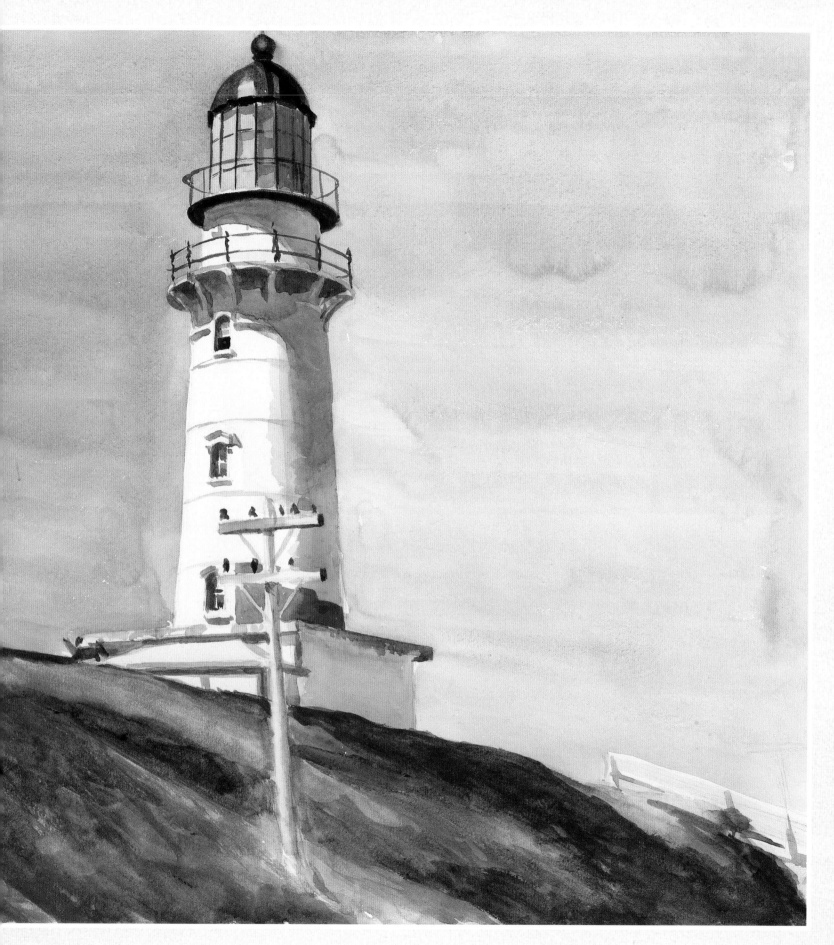

Light at Two Lights

On the Way to the Sea

Most painters of seaside scenes wouldn't think of painting a road through the countryside, but to Hopper, getting there was part of the vacation experience, and the road and the automobile a big part of American life. In many pictures, Hopper liked to include the electric poles that line the roads too, poking up at crazy angles from the flat landscape. But if you look closely you will see that there are no wires connecting them! The wires may not have looked right to him, so he just left them out!

Here, we can imagine what it is like to step out onto the bare, hot road and begin our journey, surrounded by a gently rolling landscape, stretching out into the distance to disappear over the horizon. Perhaps the sea is just over that hill!

High Road

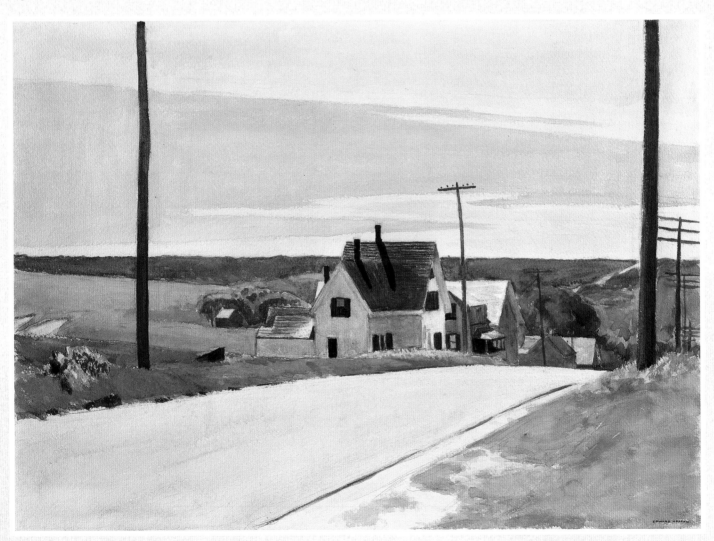

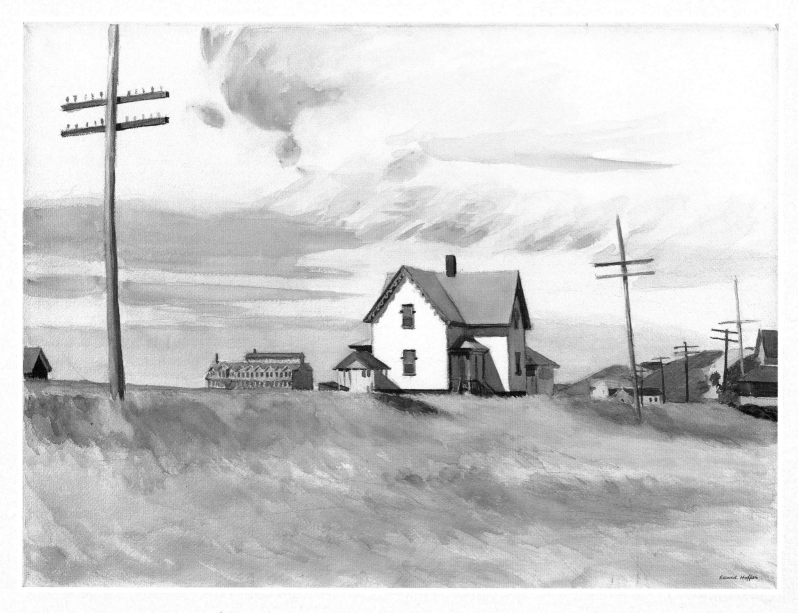

Capron House

Though he usually painted these watercolors on the spot, Hopper also made sketches and lots of notes to help him remember the effect he wanted to create when he was back in his studio. "More red on this side of road," he scribbled, or "very big shadow." As well as the roads and the rolling countryside, Hopper liked to paint many other things he passed on his way to the sea.

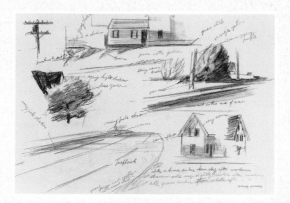

Studies for Route 6, Eastham

The Gas Station

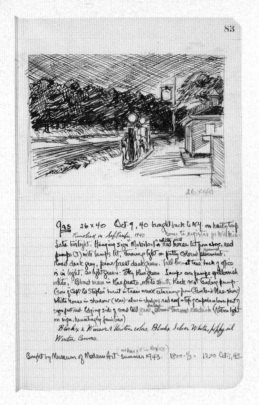

Record book, showing the page
for this painting called "Gas"

Hopper loved the businesses that lined the roadside, especially motels and gas stations. In this painting, dusk is falling and the attendant is closing up for the night. The road seems a bit spooky— what could be at the end of the road beyond those dark woods, we wonder? Hopper loved the look of trees when it was getting dark—"trees are like theater at night," he once said.

The artist and his wife often went to the theater and to the movies, and many of his paintings seem to tell stories too—but not stories that have a definite beginning and end. The scenes often make us want to think up our own tale. Who is the man at the gas station? Has he done much business today from the tourists on their way to the seaside? It doesn't look as though many cars pass this lonely spot. Will anyone be waiting for him at home, or through the doorway we can see, where a welcoming light glows?

Hopper went to a gas station near his home at the beach to find inspiration for this painting. He sketched all sorts of details—such as the pumps, the sign with the flying horse, a gas can— in order to have what he needed to create the scene. Hopper's paintings are made with just enough detail to make you feel sure you recognize the spot, although many of his paintings are not of real places! A friend of his once said that when asked where the places were, Hopper would tap his forehead and say: "In here." They were places he dreamed up, made from pieces of different things he'd seen, or feelings he might have had about a place he'd visited.

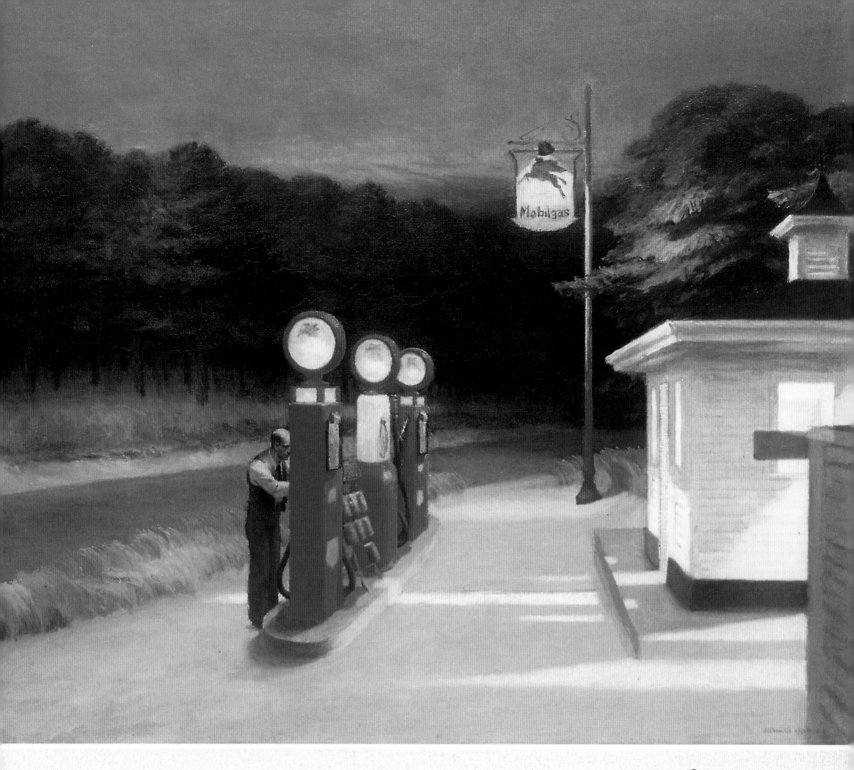

Gas

Jo once described the sign in this painting as "hauntingly familiar." These words appear in an old record book in which Hopper kept track of all his paintings. Sometimes we forget that being an artist is also a job, and you need to make a note of what you've made, who bought it, and how much it sold for. Jo helped her husband—he made the sketch and she wrote a description of the painting in her curly handwriting. She often dreamed up stories about the figures in the paintings, who they were and why they were there, filling in the details that Hopper had kept out of the painting itself.

Sailing

Jo didn't let her husband sail by himself, but Hopper's childhood love of boats never left him. His boyhood dream of building boats shows in the picture at right in which he pays more attention to the details of the masts and rigging, and to the way the wind catches the sails, than to the two men who sail the boat. Hopper called the painting "The Martha McKeen of Wellfleet" after a friend who sometimes took him sailing, even though there was never really a boat with this name! The sails billow out with the wind behind them and the boat lies low in the surf with its bow slicing through the water, which itself seems as thick as soup. Lively little gulls are lining up in a row. They are looking toward the sun and pointing the way to the open ocean. Out at sea, where the sky meets the land, there is a cool and silvery light.

Study for Yawl Riding a Swell

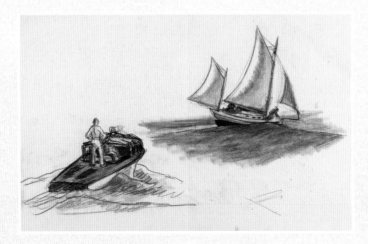

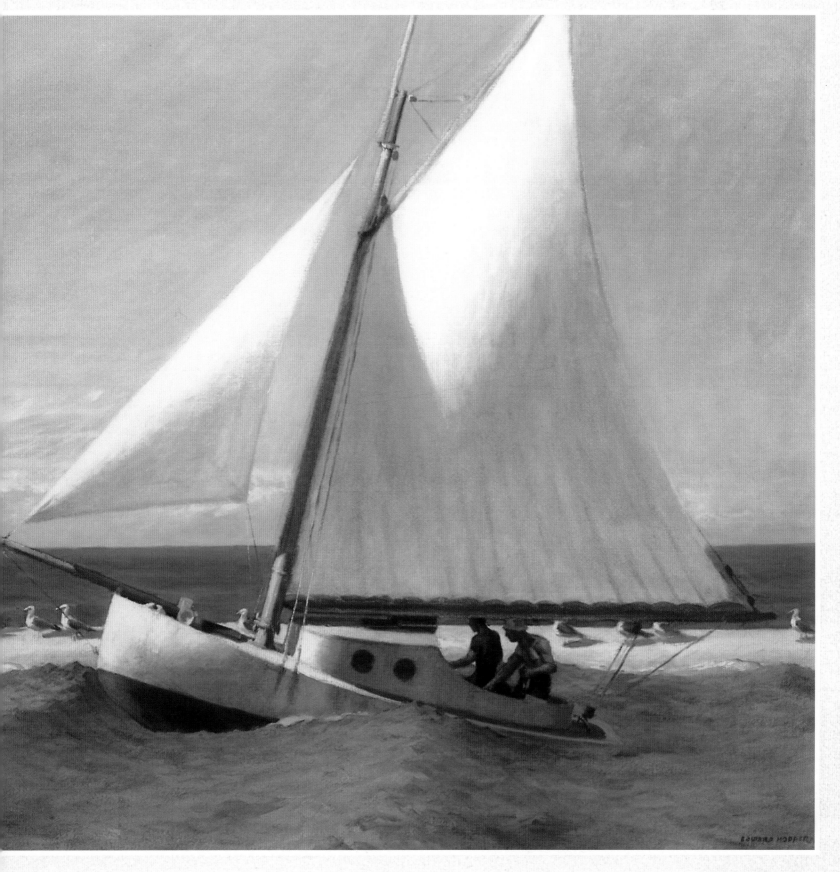

The Martha McKeen of Wellfleet

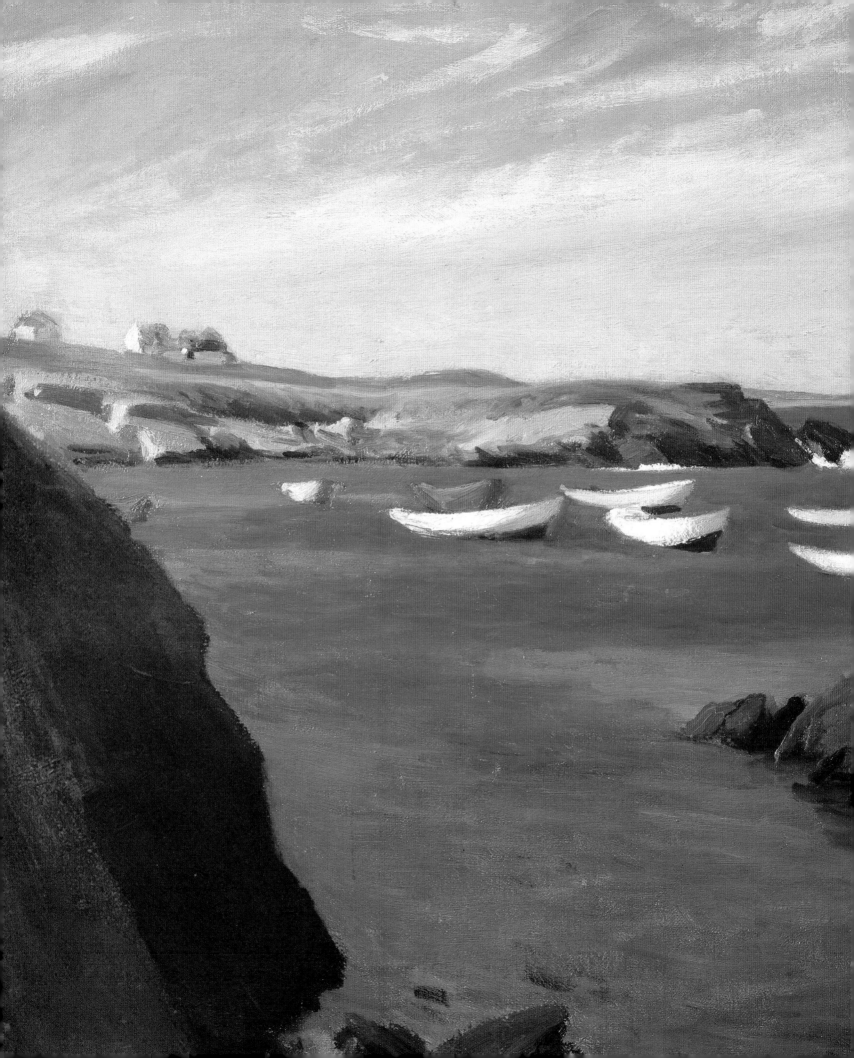

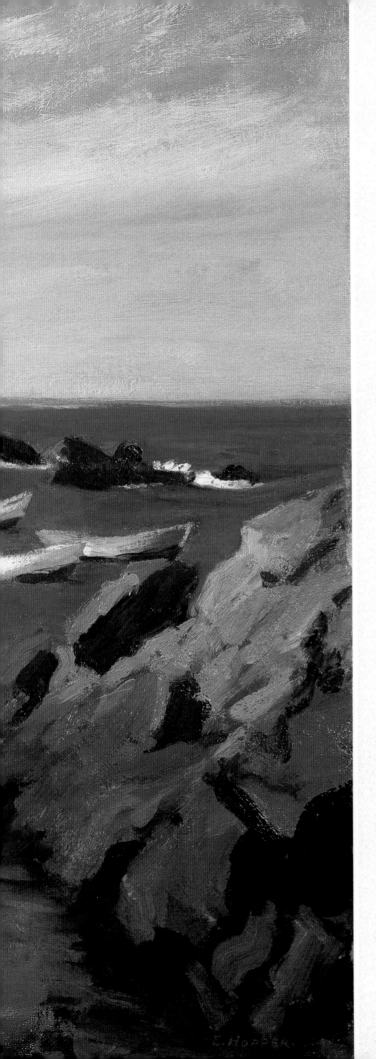

Along
the Coast

The bold little paintings Hopper made on Monhegan, an island out at sea off the coast of Maine, show us the power of the surf. Though the seaside is a place where we can relax from our busy lives, it is also a place where we are reminded of the forces of nature. In our cities and towns, it is easy to forget about the natural world. Here on the coast, the weather and tides of the ocean still shape the way people live.

In "The Dories, Ogunquit" (left), painted farther south along the coast, the sea seems to be calmer, and the little flat-bottomed boats—or dories as they are called—moored in the cove are rocking gently in the brilliant blue ocean. No boat owners disturb this quiet scene, which we peek at from behind a dark rocky outcrop in the cove. Just imagine how the rocks might feel—they are probably cool and slippery. The clouds are hurrying along in a breeze, and it looks as if it is getting colder.

below: Two of the small pictures painted on Monhegan

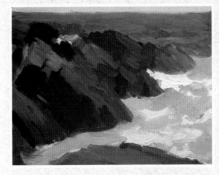
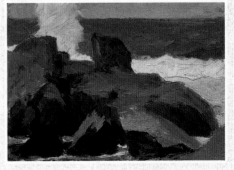

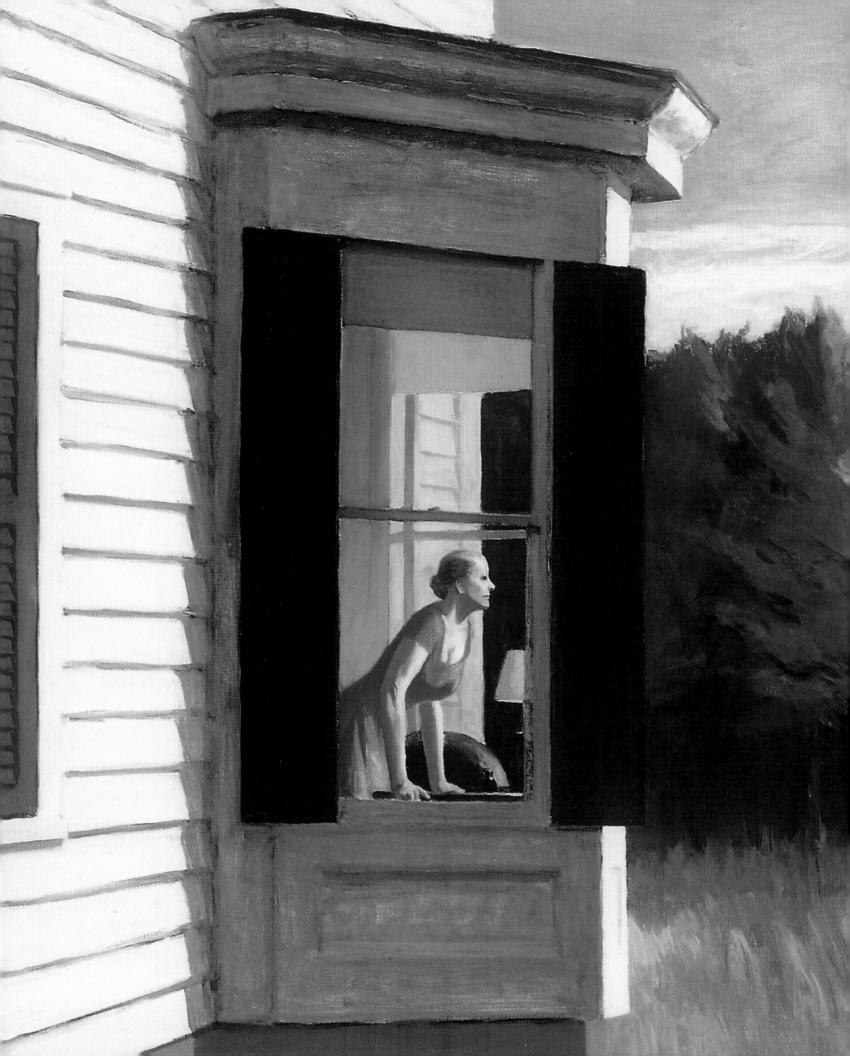

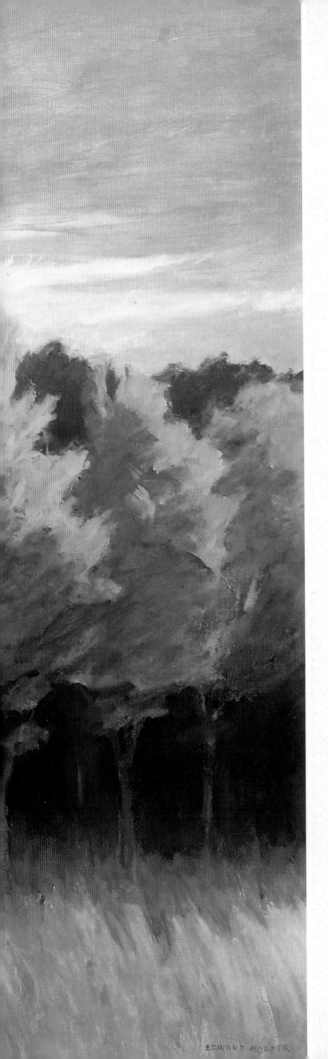

Living Near the Shore

The bright light of the coast, the endless expanse of the sea, the plain architecture, and rugged landscape, were all subjects for Hopper's paintings. Sometimes he combined these things to create the setting for his paintings of people. In this picture called "Cape Cod Morning," a woman is looking out of the window. It is early in the day, and the sun has not yet warmed the air outside. The trees are still partly hidden in the darkness, but the sun is already shining on the side of the white-painted house. The morning light makes the lines and angles of the house look crisp and sharp, which together with the yellow of the grass, provide a contrast to the cool blue of the shadows and the velvety black of the shutters.

Here, the sun is shining directly onto the woman's face, and as in many of Hopper's paintings, there doesn't seem to be any glass in the window! A lot of guesses have been made about what she is looking at, and what she is thinking about. It seems to many people that she is waiting or wishing for something to happen. Jo said she thought the woman was just checking the weather to see if she should hang out the washing, but Hopper himself claimed that she was simply looking out the window with nothing particular in mind. The woman is holding tightly onto the table, and almost seems about to spring through the window and run off to the beach. Or perhaps she would like to go back to the city because she is bored in her house at the seashore.

This was one of Hopper's favorite paintings. He made many pictures of people who look dreamily, or longingly, toward light. It had a special meaning for him—but he said that it was not important to know exactly what that is. The important thing is what a picture means to us when we look at it.

Cape Cod Morning

Land
and Sea

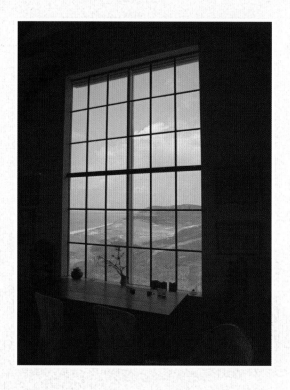

In the artist's house at the seashore, you can look out of a huge window to the grassy dunes and the bay beyond. The shape of the dunes, rounded by the wind and the sea, the yellowish greens of the grass, and the cool blue of the sea, all appear in paintings as well.

Hopper's Window

The view outside Hopper's window stretched down the coast and out to sea. In his paintings he lets us see a little slice of his world, and uses the edges of his canvas like a window frame. When we look at the above photograph of the sea from Hopper's window, we know that if we leaned out a little bit further, we would see the sea all around. In this little painting of a dune it is also easy to imagine the ocean stretching way beyond the right edge of the paper. Hopper gives us a sense of the size of the ocean and sky even in a small watercolor.

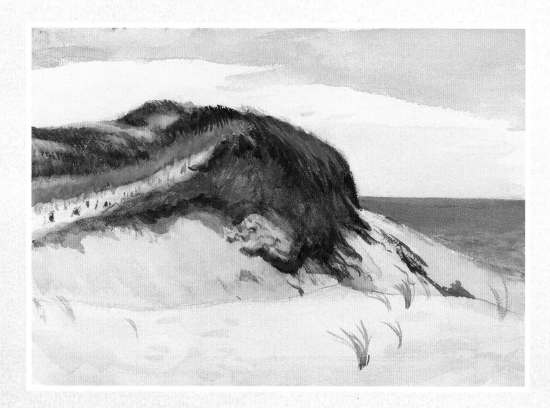

Dune by the Sea

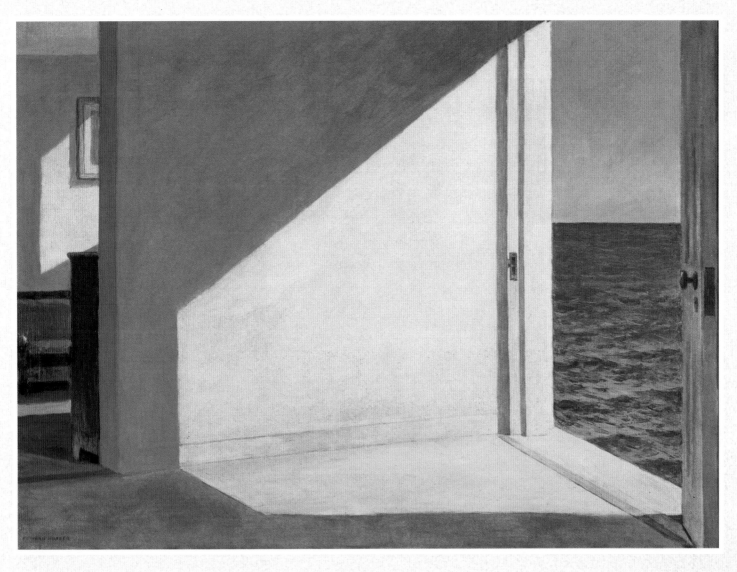

Rooms by the Sea

Hopper had a wonderful gift—he could create a world of great mystery for us just by showing things we know in a different way—a way that makes us stop and think about what we see around us. In "Rooms by the Sea," you feel as though you could step right out into the sea from Hopper's studio door. You may really be able to see the ocean in this way from a certain angle in the room, but such a scene still feels more like a dream to us. Hopper's work is about more than what he can see out of the window or along the seashore. It is about what he thinks and feels as well.

For more than thirty years, Edward and Jo Hopper spent most summers in the same place off the coast of New England, painting the buildings and lighthouses, boats, and the ocean, in a way that makes them much more than just records of this small coastal area. When you next go to the sea, you may find yourself thinking of Hopper's paintings as you look at the boats and the water, and the way light falls on the buildings and the sea. And you may find that Hopper's pictures, which contain a lifetime of memories, let you relive your own summers at the seashore.

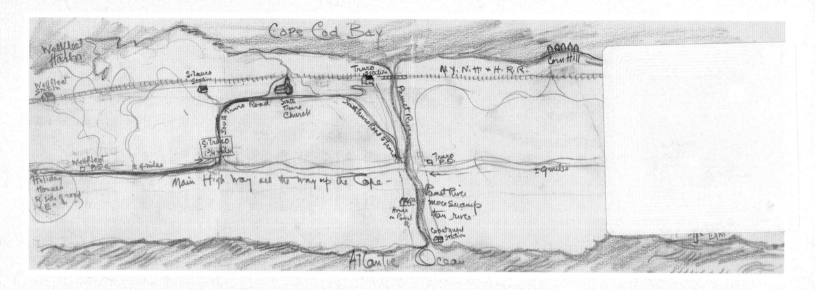

Map of Cape Cod by Jo Hopper

The Artist's Life

Edward Hopper was born on July 22, 1882 in Nyack, New York. After studying illustration at the New York School of Art, he worked as a commercial artist and illustrator. Hopper started to paint on his summer vacations in Gloucester, Massachusetts and moved into a studio in New York City in 1913. On July 9, 1924 he married Josephine Verstille Nivison, who was also an artist. Hopper gave up his commercial work in 1925, and began to work in watercolor. He also etched and painted in oil and took part in an increasing number of art exhibitions. Edward and Jo Hopper spent their summers in Rockland, Maine and Gloucester, where they both found many motifs to paint. In 1930 they spent their first summer in Truro, Cape Cod, Massachusetts, and returned most summers. They built a house and studio to their own design in South Truro in 1934. A big show of Hopper's art work was held in 1964 at the Whitney Museum of American Art, New York and at the Art Institute of Chicago. Hopper died in his Washington Square studio on May 15,1967.

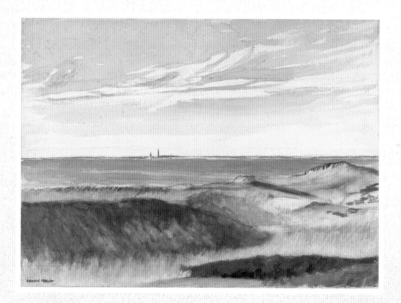

Cape Cod Bay